IMAGES
of America

WAVERLY AND
THE WAVERLY
COMMUNITY HOUSE

WAVERLY COMMUNITY HOUSE, 2008. "Those only deserve a monument who do not need one, that is, who have raised themselves a monument in the minds and memories of men," wrote William Hazlitt. President judge of the 45th judicial district of Pennsylvania George W. Maxey quoted Hazlitt when he paid tribute to founder Margaretta L. Belin at the Waverly Community House dedication of 1920.

On the cover: Please see page 61. (Courtesy Waverly Community House Archives.)

IMAGES
of America

WAVERLY AND THE WAVERLY COMMUNITY HOUSE

Josephine M. Dunn

ARCADIA
PUBLISHING

Copyright © 2008 by Josephine M. Dunn
ISBN 978-0-7385-5670-3

Published by Arcadia Publishing
Charleston SC, Chicago IL, Portsmouth NH, San Francisco CA

Printed in the United States of America

Library of Congress Catalog Card Number: 2007943582

For all general information contact Arcadia Publishing at:
Telephone 843-853-2070
Fax 843-853-0044
E-mail sales@arcadiapublishing.com
For customer service and orders:
Toll-Free 1-888-313-2665

Visit us on the Internet at www.arcadiapublishing.com

KINDERGARTNERS, 1931–1932. "To Waverly we've come again with song, good will to show / Toward friends and neighbors we behold in this ideal abode. / Long live the donor of this house, long live her sons and kin / To see the blessing it has been to those that meet herein." So sang Waverly Community House members at their annual meeting, to the melody of "Auld Lang Syne."

Contents

Acknowledgments		6
Introduction		7
1.	Historic Waverly	9
2.	Introducing the Founders	19
3.	Building a Legacy	29
4.	Educating for the Future	61
5.	Creating a Community	81
6.	The Waverly Fair	105
Bibliography		127

Acknowledgments

When I first visited the Waverly Community House (WCH) Archives during the summer of 2007, I was seeking information on Margaretta L. Belin and Gertrude Coursen of whom I had learned while researching women's history in Scranton. I expected to find incidental material, but not the rich lode that Gertrude Coursen left of her work at the community house. The scrapbooks of 1920–1948 created by "Miss Coursen" are not only a diary of her activities at the WCH but the history of a remarkable rural educational and cultural center. When I approached WCH executive director Maria Wilson with the proposal to capture the first 25 years of WCH history as a photographic essay, Maria's enthusiasm was exciting. Certainly *Waverly and the Waverly Community House* owes the most to her and to the community house board of trustees. I am indebted to both.

I thank the following colleagues for their kind assistance: Denise Reinhart, for material on the Waverly Woman's Club; architect Edward Davis Lewis, most generous with memories and memorabilia of his father, George M. D. Lewis; Anne Davison Lewis, for Elder John Miller's picture and additional Waverly history; Dorrance Belin, for family letters documenting the 1930 memorial addition of land and buildings; and Mary Belin Rhodes and Kathleen Chamberlin Graff, for reading the text and supplying Belin family history. Special thanks are due Mary Ann Moran-Savakinus, executive director of the Lackawanna Historical Society, ever-ready to further local history research; Erin Vosgien of Arcadia Publishing, who has been unfailingly helpful in the publication process; my colleague Darlene Miller-Lanning, Ph.D., whose support photographic and otherwise is inestimable; Patricia Gross, who offered for study her vintage maps of Abington Township; and lastly but never least, my husband Anthony Kearney, who coped nobly on those days when I lived more in 1920 than in 2008. I dedicate *Waverly and the Waverly Community House* to my parents, Josephine Revere and James Franklin Dunn Jr.

Photographs are from the Waverly Community House Archives, except those designated: (LHS), Lackawanna Historical Society; (ADL), Anne Davison Lewis; (EDL), Edward Davis Lewis; and (DML), Darlene Miller-Lanning. Photographs by Pennsylvania photographer John Horgan are identified.

INTRODUCTION

The Henry Belin Jr. Waverly Community House and Park manifests a utopian dream of the Henry Belin Jr. family and honors the lives of Henry Belin Jr. and Margaretta Lammot Belin. Their dream of enriching rural community life was rooted in the philosophy of Scranton Presbyterian minister Joseph H. Odell, D.D. (1887–1963), who advocated responsible citizenship and civic philanthropy. For 12 years, Margaretta and Henry Belin Jr. heard Odell's words and knew him as friend and pastor. His notion of civic engagement played out in their lives and continues to play in the community house dedicated to both in Waverly. The Waverly Community House (WCH, during its first 25 years, established a tradition of service and philanthropy that continues to unite the residents of the Abingtons in shared purpose and goal. Generations of families still rally around the "Comm" during the October Waverly Antiques Fair, the Christmas and Easter seasons, and especially during the summer when children's vacation camps fill house and park with exuberance.

The WCH originally was not supported by township tax monies, and the trust established in 1920 by Margaretta L. Belin funded only a portion of the house's annual operating expenses. In every sense of the word, the WCH then was a true community house for which those it served shared complete responsibility for it financially and ideologically. From 1920 to 1937, house coffers were filled by proceeds from an annual fair that harnessed the creative energies of local farmers and summer residents. An annual maintenance fund drive replaced the fair and remains the WCH's primary fund-raiser in the form of a capital campaign. While Abington Township provides approximately 10 percent of the operating budget, costs are otherwise still met by those the WCH serves, through private endowments, programming, and facility rental. When Margaretta's daughter Alice Belin du Pont wondered in 1929 whether future generations would assume the burden of financial leadership, she could not have known that the labor of three generations of men, women, and children would respond in a resounding affirmative.

The story of the WCH begins in 1918 with Henry Belin Jr.'s death and his widow's intention to commemorate his life. Margaretta was persuaded to create a memorial park similar to a Colonial green in the center of the village of Waverly. In January 1919, she hosted a family dinner party honoring her grandson Lt. Nathaniel G. Robertson Jr. and his close friend Lt. George M. D. Lewis—two young pilots recently returned from serving in the United States Army Air Service in World War I. The idea of a memorial to Henry was discussed, and Lewis, who held a degree in architecture from the University of Pennsylvania, suggested a community house in the park that could, through its services, perpetually benefit and enhance village life. Margaretta liked the idea of a living monument and subsequently sent Lewis to canvass community houses in New York State and New England. When Lewis returned to Waverly, he designed the community house that stands at the heart of Waverly's historic district. It was Lewis's first commission as a rising architect.

Who was the man that Margaretta and Lewis collaborated to honor in 1919? Henry Belin Jr.'s first biographer, Col. Frederick L. Hitchcock, commended him in 1914 in his book *History of Scranton and Its People*: "His labors in the cause of afflicted humanity have been so beneficial and far-reaching that the term 'philanthropist' is not misapplied in his case." Thomas Murphy

in his book *Jubilee History . . . of Lackawanna County*, printed in 1928, agreed: "On the many important but more or less temporary organizations inaugurated for the expansion and development of community life, there were none upon which the name of Mr. [Henry] Belin [Jr.] was not enrolled, once the aim and purpose thereof had met the approval of his sound yet generous judgment."

Henry's commitment to responsible philanthropy was deeply rooted also in the conscience of Margaretta L. Belin. Profoundly engaged by issues in public health, both supported Scranton's homeopathic Hahnemann Hospital (now Community Medical Center). Henry also established the curriculum of the Pennsylvania Oral School for Deaf Mutes (now Scranton State School for the Deaf) by hiring as principal one of Alexander Graham Bell's brightest students, Emma Garrett. Of Henry and Margaretta, Garrett wrote in 1883:

> Mr. Belin . . . thinks moderate sized boarding schools must exist for poor pupils living in remote country districts. Mr. Belin said he would gladly join your organization to spread oral method throughout the United States. He is good, cultured, popular and rich and would have much influence. The miner's children who are attending the Oral day school in Scranton are so poor and dirty that Mrs. Belin supplies food, clothing and soap for most of them. Mr. and Mrs. Belin have no connection with the school beyond the interest they feel in it and the giving of their means to it.

Education was integral to Margaretta L. Belin's dream for Waverly, and the WCH's first kindergarten teacher, Gertrude Coursen, embodied the spirit of progressive education in early-20th-century America. No biography exists of this educator who taught at the WCH from 1921 through 1948. During this time, Coursen never lost sight of her social altruism and the ideals of community house work that she attributed to Margaretta L. Belin's guidance. Coursen's scrapbooks, 1920–1948, are, in fact, the scaffolding upon which the photographic history of the WCH's first 25 years is built. The community house is as much Coursen's as Margaretta's proud legacy.

By 1927, the success of the dream required additional space and Margaretta contemplated additional social and recreational buildings. The idea did not languish with her death in 1927 but became the special project of her six children who collaborated to realize it in her name. Belin family letters reveal careful thought behind the collective decision to improve social services at the community house. Paul Beck Belin was instrumental in initiating this second building campaign, but sadly neither he nor his brother Charles A. Belin lived to witness the first operating year of the expanded WCH.

After 1930, Alice Belin du Pont, F. Lammot Belin, Mary Belin Robertson, and Gaspard D'Andelot Belin remained full participants in community house life. In 1958, F. Lammot dedicated an auditorium extension to his wife, Frances Jermyn Belin. F. Lammot's son Peter honored his father in 1964 by establishing the F. Lammot Belin Scholarship to further promising careers of regional artists, musicians, filmmakers, poets, playwrights, dancers, and architects.

The WCH encapsulates the dreams of generations of Abingtons residents who have passed through its doors in search of relaxation, friendship, conversation, education, sports, culture, and theater. Moreover, the vision statement that Paul B. Belin wrote for the community house seven years after its foundation reverberates still:

> When we started the Waverly Community House . . . many people thought and told us we were dreamers. We admit we are dreamers; we have envisioned the ideal community. We belong to the order of men and women who know that the ills, blights, limitations, disabilities and curses from which human society suffers can be greatly abated, and many of them entirely eliminated . . . We see the time coming when all reasonable desires and ambitions shall enjoy a more certain satisfaction. Pessimism cannot paralyze our faith . . . We dream with our eyes wide open and every faculty alert.

One
HISTORIC WAVERLY

MAP OF WAVERLY AND GLENBURN, 1891. In 1954, historian Mildred Mumford expressed the mood of those born in Waverly: "Waverly is a state of mind. You experience it when you find yourself back to live in the place just 50 years from the time you went away from it . . . The hills are not the highest, the lakes are not the bluest . . . Academy Hill is not so steep."

PENNSYLVANIA HISTORICAL AND MUSEUM COMMISSION MARKER, 1947. In his diary (1843), pioneer-settler and Baptist preacher Elder John Miller (1775–1857) described the Abington countryside he had called home since 1802: "The town is rather hilly, well-watered, of a good soil, timber generally called beech and maple, but consisting of a great variety of other kinds of wood, very beneficial and useful for the farmer and mechanic." (Courtesy DML.)

BELIN FAMILY PROPERTIES, 1920. During the Yankee-Pennamite Wars (1769–1799), the thickly forested Abington woods were dangerous and unsettled. Around 1796, Rhode Islanders surveyed the wilderness, and trappers began to move into the area. They were soon followed by Waverly's early pioneers: William Wall, Job Tripp, and Ezra Dean. (Photograph by John Horgan.)

GLENVERLY, 1920. Wall's, Tripp's, and Dean's young township was originally called Ebbington after a Connecticut land agent who sold reasonably priced titles to the dangerous wilderness known to natives as Warrior's Path. Historian Alfred Twining relates that landholders renamed the village after an eponymous Connecticut township in Windham County. Much later, Henry Belin Jr. purchased his home Glenverly in the Abington woods. (Photograph by John Horgan.)

WAVERLY, C. 1915. Ebbington became Abington Center and then Waverly. Alfred Twining and Mildred Mumford conflict in their accounts of how Waverly was named. Incorporated as a borough in 1854 when the area boasted a population of 300, Waverly resigned its charter in 1920 to merge again with Abington Township.

11

CHARLES H. WELLES AND PAUL B. BELIN FAMILY HOMES, WAVERLY, 1920. By 1867–1868, historian Andrew B. Galatian reports proudly, "[Waverly] occupies a central position in the most extensive and productive agricultural region in northeastern Pennsylvania, whose society is comprised of highly intelligent, industrious and prosperous farmers, and is one of the most healthy locations to be found." Visible here are the homes of Charles H. Welles, and Paul B. Belin. (Photograph by John Horgan.)

MAIN STREET, WINTER 1919. George M. D. Lewis photographed these Main Street buildings that burned in 1914 and were subsequently razed to construct the Waverly Community House (WCH) and park. The 1867 borough directory listed residents and businesses, identifying the village's pioneer farmers and entrepreneurs. Third- and fourth-generation descendants of the Bailey, Chamberlain, Dean, Fell, Nicholson, Perry, Reynolds, Stone, and Wall families attended the WCH kindergarten after it opened in 1920.

MAIN STREET, WAVERLY, C. 1919. During the 1860s, businesses on Waverly's bustling Main Street included dry goods and groceries, a druggist, a hardware store, a harness and saddle maker, a watchmaker and jeweler, a stove seller, tailors, farmers, a hostler, milliners, a Bible agent, physicians, a hotel, a tinsmith, a wagon maker, a furniture dealer, a blacksmith, a traveling agent, a post office, and—with a bow to the arts—an instrumental music teacher. This photograph was also taken by George M. D. Lewis.

PARKER FAMILY HOMESTEAD, 1900. The second woman to settle in the Abingtons was Mary Stone Parker around 1800. She and her husband, Stephen, built a home at Miller Road. One hundred years later, their descendants still occupied the site: from left to right are Stephen, Maximus, Walter, Robert, and Sarah Parker with aunt Sarah Giddings. (Courtesy LHS.)

PHYSICIAN ANDREW BEDFORD'S HOME, 2008. Three women milliners operated businesses in Waverly and, as did everyone, purchased groceries at six stores. All in Waverly bought medicine from druggist and physician Andrew Bedford, whose practice once included over 60 miles of rural country in the Abingtons, Dalton, and La Plume. Bedford's home, fronting the community house, is among the oldest in Waverly. (Courtesy DML.)

DR. N. C. MACKEY HOME, C. 1913. Foundry Alley ran directly behind the WCH in 1920. The alley and its adjacent properties were purchased by Paul B. Belin during the spring and summer of 1929. Houses on these properties were removed, leaving Beech Street residences to frame the southern border of the WCH park. Behind Gertrude Smith and horse Dolly, the Mackey home is visible on Beech Street. (Courtesy EDL.)

First Baptist Church of the Abingtons, Established 1802. The first church established in Waverly was by a Baptist congregation. In 1849, Elder John Miller gave the congregation a lot in the village of Waverly, and this edifice on the southeast corner of Carbondale Road is still used by the Baptists as a place of worship. (Courtesy DML.)

Waverly Free Methodist Church, 1931. Waverly's first Methodist preaching appointment was in 1832. Today's Free Methodists worship in an edifice originally constructed by Waverly's Presbyterian congregation. The African Methodist Episcopal (AME) church formed in 1844 with 20 members under Rev. James Hyatt. Today the former AME church is the residence of nationally recognized architect Peter Bohlin and his wife Sally Bohlin. (Courtesy DML.)

CARBONDALE ROAD, 2008. Two branches of the Underground Railroad passed through Waverly en route to Canada. Resident John Stone sold lots on Carbondale Road (then called "Negro Hill") to the village's first African American residents who purchased their homes on installment. Alfred Twining relates that 25 to 30 males made Waverly their home. By 1920, one descendant of a slave remained: Richard Norris. (Courtesy DML.)

MADISON ACADEMY, 1926. This 1926 sketch by Waverly architect George M. D. Lewis depicts Madison Academy, founded in 1844. According to local historian Alfred Twining, in 1920 the academy was "in its heyday . . . considered one of the principal schools of Northeastern Pennsylvania," providing education to Lackawanna, Luzerne, Wyoming, and Susquehanna Counties. When the academy was damaged by storm in 1896, a graded school was erected nearby. (Courtesy EDL.)

JAMES A. LINEN JR. (1884–1957). Among the first Scrantonians to summer in Waverly were Henry Belin Jr. and Scranton banker James A. Linen Jr., both of whom prompted a period of gentrification in the village from 1895 through 1920. Linen inspired business associates (John Simpson, Charles H. Welles, James Oakford, James S. McAnulty) to build family retreats in the Abingtons as well. (*History of Scranton and Its People*, vol. II.)

JAMES A. LINEN JR. HOME, WAVERLY, UNDATED. Alfred Twining reports that summer homes and lush gardens "equal to those of any famous resorts in the United States" made Waverly the "tuxedo of Scranton" by 1920. He cites their stately names: Welbeck (Charles H. Welles), Overlook (Mortimer Fuller), Lenni (Paul B. Belin), Glenverly (Henry Belin Jr.), Storbel (Charles A. Belin), All View (Gaspard D'Andelot Belin), Woodside (F. Lammot Belin), and Blairmont (James A. Linen Jr). (Courtesy LHS.)

17

"ABINGTON," BERTHA COLVIN LISTER, 1921. Those who moved to the Abingtons permanently or summered here were drawn by cooler temperatures and the landscape's seasonal color. One resident was composer Bertha Colvin Lister of Glenburn, who dedicated "Abington" to Margaretta L. Belin in 1921. The song opens with the chorus "We sing of thee, dear Abington, / our native home so fair, / Thy lakes and rills, thy fertile hills, / All gifts of His bountiful care."

WAVERLY RESIDENT JO PASQUARIELLO, 1937. The first verse of "Abington" continued, "Our fathers toiled of old in summer's heat and winter's cold, / To conquer the wilderness, / Our mothers, kind and true, stood their share of hardships, too, / To make this the land of the blessed." Little remains today of rural Waverly that resident Jo Pasquariello knew, since construction of the WCH in 1920 ushered in the dawning era of automobiles and suburbs.

Two

Introducing the Founders

WINTER IN WAVERLY, 1921. Upon her husband's death in 1918, Margaretta L. Belin determined to honor him in a perpetually giving manner by donating land and a community house to the village that her husband cherished and admired. Today's WCH is 12 years shy of its 100th anniversary.

WCH, 1923. Margaretta L. Belin's deed of gift reads, "That the township of Abington, through the Board of Trustees, shall reasonably maintain the [Henry Belin Jr. Waverly] Community House and Park, Margaretta Belin agreeing during the year 1920 to personally contribute to the support and maintenance of the said house and park . . . thereafter she will establish . . . a fund,

the income of which shall be paid . . . to the said Board of Trustees so long as the property herein deeded is used for the purpose of a community house and park for the benefit of residences of the Township of Abington." Margaretta lived to see the WCH through its first productive seven years.

Margaretta L. Belin (1846–1927). Alfred Twining, WCH historical committee chairman in 1922–1923, penned a series of articles on historic Abington for October 1920 issues of the *Scranton Times*. His opening essay honored WCH founder Margaretta L. Belin "whose annual benefaction [had been] for years furnishing . . . finances for the [Waverly] community picnic at Lake Winola during the summer season." This oil portrait is signed B. Equiz, 1928.

HENRY BELIN JR. (1843–1918).
Margaretta's husband was Scranton's
E. I. Du Pont de Nemours and Company
of Pennsylvania director, trustee-
treasurer of the public library, financial
consultant for Hahnemann Hospital,
and president of Scranton's school for the
deaf. "Modest and retiring in disposition
[but] forceful and practical in reality,"
stated Col. Frederick L. Hitchcock, "his
highest ambition [was] to be useful to his
fellow men." This undated oil portrait is
signed Lenrique. (*History of Scranton and
Its People*, vol. II.)

PAUL B. BELIN (1875–1929).
Margaretta and Henry's son Paul B.
Belin graduated from Yale in 1895
and pursued postgraduate work in
architecture at Columbia University.
For a couple of years, he practiced
as an architect before becoming
treasurer and general manager of the
Scranton Lace Company in 1898.
Representing the Belin family, he
engaged architect George M. D.
Lewis to design the WCH in 1919
and its addition in 1929. (Photograph
by James B. Schreiver.)

RECREATIONAL BUILDING, SCRANTON LACE COMPANY, SCRANTON, C. 1910–1915. Local newspapers described Paul B. Belin as "intensely interested in everything pertaining to civic welfare and progress, a great friend of the people, rich and poor." He constructed a gymnasium and recreation hall on-site for Scranton Lace Company employees and opened the private pool of his Waverly estate, Lenni, to them several days a week during the summer. (Courtesy LHS.)

THE WAVERLY SCHOOL, DAVIS AND LEWIS ARCHITECTS, 1926. WCH board president Paul B. Belin was also instrumental in securing the bond issue that funded the new $150,000 Waverly School dedicated in November 1926. When Belin was planning enlargement of the WCH in 1929, he reminded Alice Belin du Pont, "Don't forget that the school and community house have to be worked as close together as a pair of Siamese twins."

GRADED LAWN FACING BEECH STREET, 1930s. At the age of 54, Paul B. Belin died suddenly of surgical complications on February 27, 1930. He had spent most of 1929 quietly purchasing properties behind the community house to increase the greensward toward Beech Street. Newspaper editorials praised Belin, "who year after year placed on the altar of public use and quiet charity so large of the success won by himself."

WAVERLY BOY SCOUTS, 1933. When promoting a community house to Waverly citizens, Paul B. Belin had observed, "Social service is possibly one of the biggest problems affecting our agricultural regions, and it is the lack of this service that is causing so many men to leave the farm to go into industrial plants of the cities." By promoting the Waverly Grange and in sponsoring Scouting, the WCH supported rural life.

CLASSROOM IN WAVERLY HIGH SCHOOL, 1930S. Paul B. Belin's sister Alice Belin du Pont (1872–1944) had already contributed much to the WCH before Paul engaged her interest in a family donation of wings to the community house in 1930. In 1926, she had donated a 48-seat bus to the Waverly School, thus saving many a village child the arduous walk to and from school during snow-filled winters.

F. LAMMOT BELIN (1881–1963). Paul B. Belin's brother F. Lammot donated land for the Waverly School, and on November 11, 1926, the new school was the first of three planned buildings to be dedicated. In 1964, Lammot's son Peter (died 1982) established the F. Lammot Belin scholarship in honor of his father to support rising artists, poets, filmmakers, musicians, and authors. To date, 44 grants have enriched cultural life in northeastern Pennsylvania.

FRANCES JERMYN BELIN (1888–1945). In 1922, Lammot's wife Frances funded the WCH nurse whose duties were made official by WCH trustees in 1925. The nurse maintained daily office hours (from 8:30 a.m. to 5:00 p.m.), provided home health care, delivered monthly health lectures at the Waverly School, and assisted at the community health clinic. The new auditorium extension of the WCH was dedicated to Frances by Lammot in 1958.

YOUNG JANET STORRS (LITTELL) AND ELIZABETH STORRS (BELIN), 1897. On April 6, 1922, Charles A. Belin offered WCH trustees a Westinghouse radio receiving outfit in memory of his wife Elizabeth Storrs Belin (died 1921). The set was kept in the library and secretary Gertrude Coursen reported community house children receiving messages from 65 sending stations, including Cuba and several in China in 1923. (Courtesy LHS.)

MARY BELIN ROBERTSON AND ELIZABETH JERMYN WHITE, 1931. Mary Belin Robertson (left), nicknamed May, was not eager to see the WCH expanded at the risk of compromising Waverly's character and identity as a village. Nevertheless, she was an untiring contributor to WCH life, annual fair planner, volunteer, exhibitor, and prize winner. In this photograph, she tends the flowers sale booth at the fair of 1931.

GASPARD D'ANDELOT BELIN (1888–1954). Gaspard D'Andelot Belin, called Don (second from left), offered the second family donation of land and buildings to WCH trustees in honor of Margaretta L. Belin, and the deed was presented to William Smith (far right) representing Abington borough. Other dignitaries at the dedication of May 17, 1931, include, from left to right, Donald Belin, United States senator David A. Reed, and United States representative (11th District) Patrick. J. Boland.

Three

BUILDING A LEGACY

WCH FROM SOUTHWEST, 1923. A community house in every sense of the concept, the WCH was headquarters for the village supervisors, school board, Waverly Grange, PTA, and Boy and Girl Scouts. It also was the ceremonial site of Waverly High School commencements, and sometimes a parish hall. Today it is an educational, cultural, and recreational center as well as Waverly's poll at election time.

PLAYGROUND, 1934. WCH educational and recreational initiatives were allied with national efforts promoting physical training for America's youth during the early 20th century. F. Lammot Belin, Scranton city councilman, lobbied unsuccessfully for more recreational parks in rapidly industrializing Scranton of 1913. In Waverly, his family successfully promoted in 1920 what he could not in Scranton: a community with a recreational park at its heart.

WCH, 1930s. WCH secretary/administrator Gertrude Coursen stated, "Many other communities are hoping and working that they too may have community houses. In a measure they are looking to us. May we always remember that 'It's the spirit that counts,' that the WCH may be one of true Happiness, Example and Service." By 1925, the WCH had achieved national recognition. (Photograph by John Horgan.)

"RURAL PLANNING," 1925. News of the WCH reached a national audience through the March 1925 cover of United States Department of Agriculture Farmers' Bulletin No. 1441, "Rural Planning, the Village." Author Wayne C. Nason selected the WCH as an example of what a community could do to improve itself. Paul B. Belin wrote that Pennsylvania's governor also was "intensely interested in [community house] work . . . and wish[ed] it to spread throughout the state."

SCRANTON TIMES CARICATURE OF JOSEPH H. ODELL, D.D., 1913. The WCH was dedicated by Gov. William Cameron Sproul (1887–1928) on June 25, 1920, and embodied the philosophy of responsible philanthropy advocated by Dr. Joseph H. Odell. Former pastor of Scranton's Second Presbyterian Church (1902–1914) and close friend of church trustee Henry Belin, Odell preached, "The most valuable investment of any community is the health and welfare of its citizens."

AERIAL VIEW OF WCH, 1920S. "Monuments are not just set up where birds can roost on them," iterated Gov. William Cameron Sproul at the dedication, "[and should not] be left by private philanthropy or in memory of soldiers who have given their life for their nation . . . This house should be a political 'hatchery' for the solution of problems." Indeed from 1920 to 1945, the WCH was exactly that.

JUDGE GEORGE W. MAXEY. In his dedication speech, Judge George W. Maxey explained *community* to his Waverly audience: "When you are asked to support good roads, adequate municipal or county buildings, do not think of self or of the few dollars and taxes that self pays. Think of the interest of the community to which we all belong, and to which we owe so much of our well-being." (*History of Scranton and Its People*, vol. II.)

NOTICE FOR LAYING THE CORNERSTONE, 1919. The ceremonial laying of the cornerstone took place on July 26, 1919, one year before the dedication. Song and prayer framed the address delivered by the president judge of the courts of Lackawanna County Henry M. Edwards, a Welshman widely admired for his oratory. Edwards, a former employee of the *New York Tribune*, purportedly authored features on life in burgeoning Scranton in 1864–1865.

NOTICE

The people of Waverly Borough and Vicinity are invited to attend the Exercises on

SATURDAY, JULY 26, 3:30 P. M.
At the
Public Square, Waverly Borough
At which time the Corner Stone of the
Waverly Community House
Will be laid

A building presented to the people of Waverly Borough by Mrs. Henry Belin, Jr., in memory of her late husband.

LAWRENCE'S BAND
of 28 pieces will furnish the music

PROGRAMME
DR. N. C. MACKEY—Chairman.

Opening Patriotic Song	Fifty Girls
Prayer	Rev. Lowery
Selection	Lawrence's Band
Laying of Corner Stone.	
Address	Hon. President Judge H. M. Edwards
Selection	Lawrence's Band
Patriotic Song.	
Address—"Our Boys"	George E. Stevenson
Selection	Lawrence's Band
Closing Song.	
Benediction	Rev. Edmuns

Following the above program there will be Dancing and Refreshments.

COMMITTEE

GEORGE M. D. LEWIS (1891–1987). WCH architect George M. D. Lewis held a degree in architecture from the University of Pennsylvania. During World War I, he was a pilot under Capt. Fiorello La Guardia in Italy. After the war, Lewis practiced architecture in Scranton and lived in Waverly. When commissioned to design the WCH, he was in partnership with local architect Edward H. Davis. (Courtesy EDL.)

ARCHITECT GEORGE M. D. LEWIS. George M. D. Lewis designed several variations on a Federal-style redbrick building. The selection of style was symbolic and corroborated Dr. Joseph H. Odell's thoughts on patriotism and civic responsibility: "In going back to the sources of our national greatness we may become inspired by the same motives that led to the service and sacrifice of our forefathers." (Courtesy EDL.)

PLAN OF FIRST FLOOR, WCH, 1919. The first floor comprised a post office and postmaster's office, a small cafeteria, a comfortable lounging hall, a periodicals and reading room, the women's club room, a bright sun parlor, a large meeting hall (combination auditorium and gymnasium), a restroom, a pergola, and two terraces overlooking both tennis courts and playground.

LOUNGING HALL, 1920. The lounging hall today is devoid of furniture and is used as a reception lobby for the WCH. The former post office space adjacent to the hall now operates as a small snack room with soda and candy machines and is serviced by the original cafeteria that remains on-site. Replacing the women's club room is a large men's restroom. (Photograph by John Horgan.)

PERIODICALS AND READING ROOM, 1920. The reading room opened into the lounging hall and became a comfortable extension of it. Both rooms reflected the purpose of the building that Paul B. Belin described in 1920 "as a place where all can meet, where anyone inclined can write letters, read or have social diversions." Today the room opens onto the east portico and wing. (Photograph by John Horgan.)

WOMEN'S CLUB ROOM, 1920. Two women's clubs operated from the WCH: the Mother's Club and the Waverly Woman's Club. Primarily the women required a meeting and lecture space and a welcoming, homelike room in which to serve tea and entertain. It was also a room where school initiatives were planned and expedited by Waverly moms. (Photograph by John Horgan.)

WAVERLY TEA GARDEN
WAVERLY COMMUNITY HOUSE
WAVERLY, PENNA.

Clean, Sweet, Appetizing Menus served daily from 2 until 9-30 P. M.

THIS offers an opportunity for an ideal short restful drive, the road being excellent from the city right up to our door, as the Clark's Green route to Waverly has just been completed.

Pool Tennis Bowling
A Playground for the children.

WHY NOT RUN UP TO SEE US SOME AFTERNOON OR EVENING?

ADVERTISING THE TEA GARDEN, 1920s. Proud of the new state road that connected Waverly to Clarks Green and Scranton, the WCH advertised the amenities it offered travelers: pool, tennis court, bowling alleys, and especially a tea garden where food was served from 2:00 to 9:30 p.m. At the annual fair, Waverly Girl Scouts sold tea garden delicacies at their booth to raise money for the WCH maintenance fund.

SUN PARLOR, 1920. The light-filled sun parlor exists only in memory and through John Horgan's elegant photograph. The parlor was often used by kindergartners at play. When the east and west wings of 1930 were added to the WCH, the sun parlor was replaced by an arcaded portico connecting the east wing to the original building. (Photograph by John Horgan.)

POST OFFICE AND CANTEEN, 1920. In 1924, postmaster Annie Smith encouraged frequent use of the post office to raise it from fourth to third class. (Sale of 1,500 stamps yearly effected such a change.) By 1928, Waverly's third-class post office boasted a "catcher pouch," which was caught by the crane of a fast train and ensured speedier postal service. From 1920 to 1929, Beatrice Lewis ran the WCH canteen. (Photograph by John Horgan.)

37

WARREN BERRY AND GRANDCHILDREN GETHINE AND FRANCES GRAVES, 1923. WCH mail carrier Warren Berry worked alongside Waverly's first postmaster, Louise Parker (1920–1923), and her successor, Annie Smith (1923–1932). Secretary Gertrude Coursen described Berry to the trustees as a happy fellow who entertained all by singing as he worked. She also informed trustees that as use of the post office increased, so did the weight of cheerful Warren's mailbags.

AUDITORIUM, 1920. This is the appearance of the auditorium before the side and stage extensions were added in 1930 and 1955. When the Waverly Methodist Episcopal Church burned in 1921, WCH trustees offered the congregation use of their 250-seat auditorium for Sunday services. Not only did this space accommodate theaters, concerts, dances, and church services, but it was a sports center and gymnasium as well. (Photograph by John Horgan.)

WAVERLY HIGH SCHOOL COMMENCEMENT PROGRAM, 1930. Waverly High School's first commencements were staged in the community house auditorium. In 1930, the commencement speaker was Rev. Peter Kenneth Emmons of Scranton's Westminster Presbyterian Church who addressed students on "the Fascination of the Unknown." Who dreamed at that time that a second world war lay dormant on the horizon?

PLAN, SECOND FLOOR OF WCH, 1919. The second floor comprised public and private spaces. The bedroom, bath, kitchen, and dining room were reserved for the exclusive use of resident secretaries. On the opposite side of the hall, the library served as council chamber for Waverly Borough, and a movie projection booth opened into the upper spaces of the first-floor auditorium/gymnasium.

WCH CIRCULATING LIBRARY, 1920. The library committee was one of six standing committees, house, civic, social, finance, and law and order being the others. It purchased books approved by the board of trustees and made regulations for use of this circulating library. In 1923, secretary Gertrude Coursen reported the circulation of 1,923 books. Today the room is used as an archive and all-purpose meeting room. (Photograph by John Horgan.)

ADVERTISING THE LIBRARY, 1938. Waverly Girl and Boy Scouts reorganized the library in 1938, advertising new bibliographic activities and expanded hours of operation. Story hour took place on Tuesday mornings, and competitions were held during the summer to encourage reading. Some books on the reading list are still familiar (James Fennimore Cooper, *The Last of the Mohicans*), but others are less well known today (Charles Kingsley, *The Water-Babies*).

SECRETARY'S SITTING ROOM, 1920. On George M. D. Lewis's second-floor plan, the secretary's sitting room is possibly identified as the small second bedroom. WCH secretaries were provided office space in the form of a sitting room, where they could escape the din of children, quietly develop their programs, and plan the monthly calendar of events. Today the room is used as an office. (Photograph by John Horgan.)

PLAN, BASEMENT LEVEL OF WCH, 1920. The basement level of the WCH contained recreational and service-oriented spaces: a Boy Scout meeting room, a billiard room, a general playing space, two bowling alleys, two card tables, a canteen, a barbershop, toilets, a men's shower room, an icehouse, storage areas, as well as rooms for the waterworks, boiler, and fire department. Two exterior playground shelters offered youngsters protection on rainy days.

BOWLING ALLEYS, 1920. John Horgan's photograph of the basement reveals two bowling lanes and an adjacent billiard table. WCH trustees learned that, according to Pennsylvania labor law, community house children could not be hired to restack the pins. Trustees advised parents that they could only hire appropriately aged workers. Both men's and women's bowling leagues kept this room loud with merriment and competition. (Photograph by John Horgan.)

MEN'S RESTROOM, 1920. The men's restroom was located in the basement while the women's restroom was on the first floor. The gleaming porcelain fixtures were state-of-the-art in 1920, and the room opened directly into the men's shower room. Although Waverly's women were encouraged to be athletic, they did not enjoy the amenity of a public women's shower room at this time. (Photograph by John Horgan.)

WAVERLY WINTER, 1930s. Originally annual reports were delivered to WCH trustees and members by the secretaries in January or February. By 1930, representatives of many children's organizations were also giving oral reports. Young John Hull, representing the Elves Club, reported that the "elves" had brought a Christmas tree from the woods and decorated it for the birds in memory of "all Mr. [Paul] Belin did to make the little children happy."

WCH BYLAWS, 1925. The WCH was run by a board of nine trustees who hired and supervised community house personnel. The first trustees were appointed by Margaretta L. Belin and the borough, but a process of nomination and election soon developed that gave the responsibility for nomination to Belin family representatives and borough, and election to members. Shared responsibility united Waverly in purpose and goal.

BY-LAWS

OF THE

Board of Trustees of the Waverly Community Building

WAVERLY, PA.

TRUSTEE BALLOT, 1922. From the outset, WCH annual meetings comprised the board president's report and committee reports, as well as rousing entertainment while ballots electing new trustees were being counted. For example, the "crack minstrel troupe of the Scranton Lace Company" performed comedy and song in 1922. Eight candidates were elected, Paul B. Belin garnering the most votes, and the new board elected a ninth member to its body.

BALLOT
ELECTION OF TRUSTEES
WAVERLY COMMUNITY HOUSE
JANUARY 16TH, 1922
VOTE FOR FOUR ONLY IN EACH COLUMN

NOMINATED BY THE WAVERLY SUPERVISORS		NOMINATED BY MRS. HENRY BELIN, JR.	
Mrs. Warren Berry	63	Mrs. C. B. Elston	79
Mrs. J. A. Linen	6	Mrs. A. W. Marvin	100
Mrs. N. C. Mackey	80	Mr. Harry Miller	94
Mr. Joseph Carpenter	102	Mr. E. H. Lowrey	38
Mr. C. L. West	38	Mr. William Smith	86
Mr. G. A. Spencer	52	Mr. William Letson	54
Mr. P. B. Belin	126	Mr. Stephen Parker	45
Mr. G. M. D. Lewis	73	Mr. C. H. Griffin	34

JUNE DANCE

under auspices of the
Waverly Athletic Association

FRIDAY EVENING, JUNE 18, 1926

at the

Waverly Community House

Music by Taylor's Orchestra

ADMISSION - - - - 50 CENTS

JUNE DANCE TICKET, 1926. The WCH operating budget for 1922–1923 was $2,096.29, and the year ended with a net profit of $205.72. In 1926, revenue to run the house continued to be raised through canteen sales, billiards, bowling, movies, dances, hall rentals, the annual fair, tennis courts, entertainments, and the barbershop. A dance admission of 50¢ swelled WCH coffers in June 1926.

MAIN STREET WAVERLY, 1928. The WCH depended on fair revenues to cover 38 percent of its operating costs. One month before the stock market crash of 1929, Paul B. Belin observed that "the general depression in Scranton may have slightly affected the [annual fair] receipts, but [that] in any event the fact that the attendance was greater shows that more interest was taken, although the people did not have much money."

GERTRUDE COURSEN, 1927. The WCH set high educational goals and hired dedicated instructors like Gertrude Coursen (right, known as "Miss Coursen"). Miss Coursen supervised daily operations, but her greatest pleasure was teaching kindergarten. No apter statement of her sentiments exists than Dr. Joseph H. Odell's pronouncement: "Happy the city that can send forth its youth with well-trained minds and high ideals, to work for the best interests of the community."

BRUCE REYNOLDS, 1930. Not just adults but children and every WCH youth group worked yearlong to raise money for the maintenance fund. Gertrude Coursen tells the story of one earnest pupil who told her, "I have . . . earned twenty-nine cents and I am going to give that to the church. Now I'll work and earn some more and give that to the community and then you both will have enough."

GERTRUDE AND CATHERINE COURSEN, 1930. By 1929, Gertrude Coursen was overwhelmed by increasing administrative duties. Addressing the problem, Paul B. Belin observed to his sister Mary Belin Robertson that Coursen was "probably the most popular girl in the village of Waverly, and [that] there could be no suggestion of supplanting her." To advise trustees on administration of the WCH, Belin invited Chicago settlement worker Neva L. Boyd (1876–1963) to Waverly for three days.

KINDERGARTEN CLASS, 1937–1938. Even after 16 years of teaching, Gertrude Coursen still inspired awe. Henry Belin III remarked in 1936, "Having a youngster attending kindergarten myself . . . I can assure you that it is more important to that child that she get to kindergarten than it is for her own Dad to get to work." Enrollment was so large by this time that Coursen was provided an assistant.

GIRL SCOUT HIKE, 1933. On April 20, 1926, the WCH received a permit to sell gasoline. Coursen preserved the original Commonwealth of Pennsylvania Liquid Fuel Permit in her scrapbook of 1926. Probably no vehicle used the pump more regularly than the WCH van, which was always departing the WCH fully loaded with Brownies and Girl Scouts, kindergartners, and Boy Scouts.

GERTRUDE COURSEN, 1930S. During a year's sabbatical (1930–1931), Gertrude Coursen spent several months studying social welfare work and community houses in Chicago and New York. From abroad, she assured the trustees, "All of the outstanding features of community centers throughout the country are incorporated in the Waverly building and program." During the second half of her year off, Coursen visited European kindergartens.

ASSISTANT SECRETARY HELEN S. FISH, 1924. Helen Fish was appointed assistant secretary in 1921 and served the WCH for five years. Her responsibilities included direction of the playground and all physical activities of the community center. In addition, she directed clubs and penned thoughtful annual reports that were delivered to the trustees informing them of the steady increase in enrollment and in the number of recreational activities.

ART EXHIBITION, 1929. Fish also became the WCH's first art teacher when she divided the Saturday morning handwork class between kindergartners and older children. Boys and girls over the age of 12 enjoyed a specialized art class. By 1929, art teacher Sally Brace was teaching pastel, watercolor, and block printing. During the annual meetings, students exhibited their work in the sun parlor, as seen here.

FRANKLIN MACLAREN, C. 1928. Director of physical education Franklin MacLaren supervised athletic classes at the community house from 1928 through 1933. Paul B. Belin was convinced by 1928 that the time had come to employ a male athletic instructor who could more easily command order from rowdy young males. MacLaren served the WCH for five years as basketball coach, gym teacher, athletic director, and Boy Scout captain.

CHAUFFEUR JOE DIXON, 1933. Joe Dixon was the ready and patient chauffeur who transported rambunctious and excited children from the community house to camping and hiking sites as near as Gravel Pond and as far as Lake Ely in Susquehanna County. Most photographs of Dixon reveal the many ways that his passengers managed to fit into his "mini-van" of the 1920s.

GIRL SCOUT CAPTAIN ANNE AVERY, 1927. WCH secretary Anne Avery (center foreground) replaced Helen Fish. A graduate of Neva Boyd's Training School for Playground Workers in Chicago, Avery began her WCH employment in 1925 as instructor in athletics and outdoor sports for both boys and girls. She also directed the plays for which Waverly's young people practiced all summer and supervised Waverly's Girl Scouts.

NURSE LILLIAN HAYDEN, 1923. The first community nurse was appointed in 1922 to serve Waverly schoolchildren and residents. Nurse Lillian Hayden's salary was donated by Henry and Margaretta L. Belin's daughter-in-law Frances Jermyn Belin, wife of F. Lammot. In 1922, Hayden made 1,441 sick calls in the community, 652 of which were requested. Lillian remained in charge of community health initiatives at the WCH through August 25, 1925.

GERTRUDE COURSEN AND MILDRED JENKINS, 1930. Mildred Jenkins (right) replaced Lillian Hayden as nurse and quickly became an essential assistant to Gertrude Coursen. Mildred's marriage to Benjamin Smith in April 1935 and their subsequent departure for Allentown deeply saddened WCH children and Girl Scouts. Trustees made arrangements with Scranton's Visiting Nurse Association to carry on Mildred's work.

MILDRED JENKINS WITH MARTHA AND ANDREW TOTH, 1934. Whereas the WCH lost an able and dedicated nurse in Mildred Jenkins, the hire of a nurse affiliated with the Visiting Nurse Association offered distinct advantages to Waverly. At weekly meetings of the associated nurses, WCH health-care givers kept abreast of recent developments in public health nursing and received the benefit of closer supervision in the preparation of their reports.

RUTH HARRISON, C. 1928. Ruth Harrison arrived at the WCH in 1928 and remained through 1937. In 1936, Gertrude Coursen informed WCH trustees, "When Miss Harrison first came to Waverly, she had a very modest amount of experience in weaving. Through her own efforts she has taught herself and is now able to pass the information along to other interested parties." Harrison supervised many craft and handwork classes.

Hahnemann Hospital, 1905. When Margaretta L. Belin died in 1927, her six children agreed to erect a memorial to her. At first, it was proposed to found a hospital, thereby honoring Margaretta's long-term philanthropic commitment to Hahnemann Hospital and her donation of a home for nurses. By January 1929, however, the concept of an enlarged community house had taken root in the family's mind. (Courtesy LHS.)

Basketball Practice, 1931. As early as 1928, WCH spaces were proving too small to accommodate all scheduled activities. Athletic director Franklin MacLaren gently complained to the trustees that the 15- to 20-game basketball season was not being played on a regulation court. He requested the enlarged court that was constructed in 1930 for these athletes.

WADING POOL, 1920S. In 1928, Paul B. Belin added that the WCH was not producing children "equipped to make good, as they should be equipped . . . Our failure," he noted, "is [that] because of the lack of space [at the WCH] we have not been able to fill their leisure hours with things accomplished as well as fun." He was speaking of a kindergarten room to balance the outdoor recreational facilities.

VIEW TO WCH FROM CHURCH STREET, 1928. "Ever since we built the Community House," continued Paul B. Belin, "we realized that in not providing kitchen and pantry, we had made a mistake." In fact, to assist food service at the fairs, Waverly churches had opened their kitchens to WCH personnel who toted food the distance seen here: from church hall and across the WCH park to the fairgrounds.

WCH Aerial View, 1920s. By summer 1929, Margaretta L. Belin's children were planning architectural additions to the WCH. Paul B. Belin reminded Alice Belin du Pont that Margaretta "was always opposed to land, as land, and wanted life." Gaspard D'Andelot Belin cautioned, "I can't see why Waverly should become another Clark's Green or Dalton. We enjoy the country because it is the country." Close deliberation brought all to agreement on enlargement of the WCH. (Photograph by John Horgan.)

WCH North Front, 1920s. F. Lammot Belin weighed in, "I have racked my brain for something else which would perhaps appeal wholeheartedly to all concerned and frankly admit that I can think of nothing . . . I think, therefore, that the proposal for an addition to the Community House is the one idea which [furthermore] would be entirely approved by Mother."

FOUNDRY ALLEY, 1920S. In early 1929, Paul B. Belin informed Alice Belin du Pont, Gaspard D'Andelot Belin, F. Lammot Belin, Mary Belin Robertson, and Charles A. Belin of his purchase of lands behind the WCH and off Foundry Alley. Paul's intention was to sell and move rather than raze the houses on the purchased lots "in order not to cut down the assessed valuation of the village." He paid $50,000 for the properties.

WCH WEST FRONT, 1920S. To finance purchase of the properties behind the community house, Paul sold 700 shares of General Motors stock from his mother's trust in June 1929. One month earlier, Paul had assured Alice that, although the market was low and could go lower, the stock had doubled in value since Margaretta L. Belin's death. His prediction of a falling market presaged the stock market crash five months later.

WCH North Front Showing Original Sign, 1920s. "While it seemed as if I did everything in an awful hurry, as a matter of fact, I have been working on this ever since April [1929], but I did not dare say anything to anybody," Paul B. Belin confided, "for fear it would leak." Additions to the community house, he wrote, were Margaretta's wishes before she died.

Proposal for Gymnasium, George M. D. Lewis, 1930. Paul envisioned a new gymnasium, separate Boy and Girl Scout rooms, two club rooms, a kitchen, and a garage for several automobiles. He worried that additional buildings would tax the ability of residents to maintain the WCH. Additional buildings meant higher maintenance costs, and nine years earlier he had already asked Waverly residents to contribute $5 until the WCH became self-supporting.

LOUNGING HALL, 1920. No mediated space for a kindergarten existed in the WCH of 1920 and the need for it was paramount. "A large 'sunshiney' room for kindergarten purposes is a real need," stated Paul B. Belin in 1929. "It does seem too bad to use the reception room for that purpose, and . . . the community house is the place for the kindergarten rather than the schoolhouse." (Photograph by John Horgan.)

TENNIS COURTS, 1920S. The tennis courts of 1920 remained part of the 1930 plan. Jean Howell, in charge of the kindergarten in 1931, described the educational value of sports: "If [children] can learn [law and order] in games, they might sometime connect it with law and order in a community. Sportsmanship, spirit of cooperation, and respect for the rules of the game are stressed."

COACH FRANKLIN MACLAREN, 1930–1931. "All [the new gymnasium] is for is tennis, handball, basketball and calisthenics, and large meetings, fairs, etc.," Paul B. Belin explained to his brothers and sisters. In fact, the WCH auditorium continues to be the all-purpose room that Paul originally envisioned since it accommodates sports, recitals, and meetings.

WCH, 1931. As the addition took shape, Paul asked Alice Belin du Pont, "Do you wish the addition to merely harmonize with the old building . . . [as] a distinct memorial to Mother—or do you wish it merely to be an addition of the old building? The Georgian architecture of the old community house . . . hardly lends itself to a large building." Ultimately two wings were added, thereby maintaining the structure's elegant symmetry.

59

BEECH STREET ELEVATION (SOUTH), GEORGE M. D. LEWIS, 1930. To design the WCH additions in 1929, Paul B. Belin proposed a Bostonian who had done some work on his Waverly estate, Lenni. Belin was persuaded by his brothers and sisters, however, to recommission the WCH's original architect, George M. D. Lewis. Today's aesthetically integrated community house bears the full imprint of Lewis's vision.

MARY BELIN (RHODES) AND CLASSMATES, 1941–1942. Alice Belin du Pont mused, "When our generation is gone, will the younger ones take up with enthusiasm what most of us have only done with money but which [the community] has done with never-ending work and patience? . . . Will the younger ones of our class give the time, trouble, and money which is necessary?" Yes, is today's reply.

Four

EDUCATING FOR THE FUTURE

KINDERGARTEN CLASSROOM, 1931. In 1921, Helen Fish clarified the unique nature of the WCH kindergarten: "In a few localities kindergarten is misunderstood. For some people I believe that children come just to be amused, as they do in a Day Nursery, but the Waverly people seem to have a true understanding of what the kindergarten means." Through the 1940s, the WCH kindergarten remained the most progressive of community initiatives.

GERTRUDE COURSEN AND THE CLASS OF 1943–1944. Gertrude Coursen described the context for her educational work in 1922: "All those who have the welfare of Humanity at Heart, realize the importance of what is being done for the children. This is undoubtedly The Children's Age." Advances in the philosophy of education and child labor reform during the opening decades of the 20th century buttressed her claim.

KINDERGARTEN, 1930. One year later, Gertrude Coursen continued, "As we plan and develop the activities of this house, keeping in mind the importance of laying the right foundation for the children, we cannot go far astray. We wish them to develop through their play strong bodies; we wish to help them through wholesome activities to become keener mentally and sound morally." The new kindergarten classroom of 1930 abetted Gertrude's goals.

Carol Tyler (Rear) and Friends, 1927. Without a mediated classroom in the 1920s, kindergartners claimed spaces on the first floor of the WCH. Educator Jean Howell informed in 1931, "New equipment is being purchased and by the time the buildings are done, the kindergarten will be a real modern progressive school room. All of the materials used are materials that offer opportunities for a child to go on and lead toward creative original thinking."

Helen Fish and Kindergartners, 1922. Justifying inclusion of a kindergarten classroom in the 1930 floor plan, Paul B. Belin stated, "I think one of the outstanding things the Community House has fostered is the kindergarten. The character-forming period of a child's life is the first 6 or 7 years. It's really the impressionable time of his whole life." Parents beyond Waverly vied to enroll their children in the WCH kindergarten.

WEST WING KINDERGARTEN ROOM, 1931. Various rooms in the 1920 community house were used for kindergarten activities. Not until the addition of two wings in 1930 was a room dedicated entirely to early childhood education. Today the former kindergarten room is an all-purpose meeting place, the Constance Reynolds Belin Room. The walls bear portraits of members of the Belin family, many of which have been reproduced in this book.

SANDBOX, 1929. In 1928, Gertrude Coursen wrote, "We hear a great deal today about the importance of the wise use of leisure time and we know the truth of . . . 'All work and no play makes Jack a dull boy' . . . We have kept [this] in mind when developing our weekly program for the educational phases of our work are closely related." These children are learning that outdoor activities offer an education too.

WCH PLAYGROUND, 1929. President of the board of trustees Paul B. Belin reiterated Gertrude Coursen's point, arguing that "much could be accomplished if we keep in mind that we want to educate through recreation. We are continually being criticized in that the children of Waverly know only 'how to play.' I wish that I thought they did know how—O, I would feel much had been accomplished."

GROUP PORTRAIT SLIDING, 1931–1932. Gertrude Coursen offered the story of one exemplary kindergartner who had exclaimed to classmates observing the colors of fish in a fishbowl. He demanded, "There is no use killing time looking at those fish . . . Shall we all get to work?" Coursen observed, "This little boy's attitude towards work is quite typical of the attitude of the average kindergarten child." Work often included collaborative play.

JUNGLE GYM, 1929. Kindergartners played on a jungle gym of yesteryear and enjoyed rotating rings, swings, and slides that have since been replaced by a state-of-the-art playground. Constructed in 1990, the new playground was funded by a Pennsylvania Recreational and Rehabilitation grant and dedicated in honor of Robert S. Leathers.

HARRY PARKER, CELIA JANICHKO, BETTY DAVIES, BOBBIE DIXON, ROSS TAYLOR, 1927. In 1923, Janet Storrs Littell donated a set of building blocks to the kindergarten in memory of her sister, Elizabeth Storrs Belin. Kindergarten children responded with a thank-you note dictated to Gertrude Coursen: "Come and see this nice kindergarten with the pictures on the black board and see the blocks, too," they urged.

KINDERGARTEN MUSICIANS, 1927. Kindergartners thanked Margaretta L. Belin for toys and invited her to visit. In turn, she enjoined "all [to] try and help everyone, especially your Mothers at home. You can run errands and put away your things just as nicely at home as you do in the kindergarten." From left to right are Carol Tyler, Bobbie Dixon, Ross Taylor, Betty Davies, George M. D. Lewis Jr., Harry Parker, Celia Janichko, and George Mundrak.

STORYTELLERS MARY L. CHAMBERLIN AND MARY LINEN, 1938. Jean Howell replaced Gertrude Coursen during the latter's 1930–1931 sabbatical and reported, "Story hour has been a very interesting project to work with . . . [and reading stories from foreign countries] stimulated a desire for reading and helped forward international friendship." Seven years later, volunteers Mary L. Chamberlin (left) and Mary Linen continue the storytelling tradition before a rapt audience.

67

PICNICKING AT THE WCH, 1933. Gertrude Coursen advocated plenty of outdoor activity, and on fine days, she and her colleagues could be seen out and about on the WCH lawns with small charges in tow. In the background of this photograph is a private home on Church Street, one of the four residential streets that frame the community house and park.

KINDERGARTEN VAUDEVILLE, 1923. The WCH civics committee chaired by Sherman Davies sponsored vaudeville entertainment by the kindergartners in 1923. Boys and girls performed a simple garden game dressed as flowers, sunshine, rain, bees, butterflies, green frogs, and a black crow. This springtime troupe strikes a pose on the front steps of the WCH.

Fairies' Outing, 1932. The WCH van is parked in front of the community house and is filled to capacity with kindergartners. Driver Joe Dixon waits patiently for the photograph to be taken before the journey off-site begins. The Fairies was a club for very young WCH members who were encouraged to play and to think of ways they could raise funds for the WCH too.

Billy Morris and Edward Jack, 1929. Besides enjoying classroom activities, kindergartners took spins in the WCH pony cart. They learned to share the cart, lead the pony, and play collaboratively. "Games in which . . . the individual feels that the success of all depends upon the manner in which he does his share, are an essential part of training for the future," Dr. Joseph H. Odell wrote and Gertrude Coursen implemented.

69

HORSEWOMAN PEGGY NORTHRUP, 1929. Older children rode the WCH pony under supervision, as does gallant young Peggy Northrup. At the Waverly Fair, pony rides brought rural life into the experience of Scranton's urban children who came to the fair by trolley, train, bus, or automobile from 1920 through 1937.

LESSON TIME, 1930. Waverly farmers supplied Gertrude Coursen with small animals for teaching purposes. During the spring, lambs often delighted the WCH kindergartners, who exchanged their indoor classroom for the pastoral community house park. No dungarees or jeans garb this group of curious children who take turns feeding the thirsty lamb.

WCH Rabbit, 1929. One Waverly resident loaned a rabbit that was maintained by WCH kindergartners in a hutch on the community house premises. Seemingly alone in this photograph, the rabbit is actually accompanied by three sets of small hands perched on the hutch roof. The rabbit, however, is oblivious of his secret and observant young audience.

Kindergartners, Mothers, and Ruth Harrison, 1920s. Gertrude Coursen annually assembled her charges for a photograph. Often boys and girls were posed on the front steps of the community house, as seen here. For each pose, a number of photographs were taken, reflecting the challenge of posing a lively group of youngsters. The poster on the door indicates the month is December, when Waverly Scouts sold Christmas seals.

BILLY LEWIS, 1930. Rarely were children posed for individual photographs such as this one of young Rev. William P. (Billy) Lewis. Son of WCH architect George M. D. Lewis, Billy edited a junior literary journal for the community house in 1936. It contained short stories, historical biographies, and cartoons and was "printed" in crayon on manila paper. The journal was "published" in an exclusive edition of one.

LOUISE LEWIS, 1930. Taking her turn and posing before a shrubbery backdrop with her hair bow at half-mast, one foot skittish, and her hands tightly clasped, Billy's sister Louise squints into the sunlight and steps onto the stage of WCH kindergarten history. "Deeze," as she was known, was one of six children born to George M. D. Lewis and his wife Bert Harsch Lewis. An artist, Deeze lives today in Tucson, Arizona.

"Take One," 1931–1932. Kindergartners sliding on page 65 are again captured on film, now in the process of becoming a formal photograph. Eventually all posed with eyes forward, hand on the shoulders of the child in front of him or her, smile in place—a symphony of apparent harmony achieved with endless patience on the part of Gertrude Coursen. Her repeated takes of the pose attest more determination than frustration.

"Little Maids (and Lads) All in a Row," 1931–1932. At last, the successful kindergarten photograph is achieved. Regularly spaced children are arranged according to height, a few glances out of line, a few smiles in place, and children standing in orderly lockstep with hands on the shoulders of the child in front of them. Gertrude Coursen, the force of law and order, has prevailed.

GROUP PHOTOGRAPH, 1929. The WCH playground was also a favorite site for Gertrude Coursen's kindergarten group photographs. Swings, jungle gyms, slides, and rotating rings provided a variety of posing opportunities, which the children seized at times with more relish than photographic decorum. Importantly, such photographs document the type of playground equipment the WCH provided its youngsters.

JOSEPH MUNDRAK, 1929. Coursen kept scrapbooks during her 28-year tenure as WCH secretary and kindergarten teacher. Not all children in the photographs are identified, but beside this photograph Coursen wrote a brief sentence suggesting indulgent fondness for this small daredevil. She wrote, "Jack Mundrak, kindergarten child who loved to climb." Undoubtedly he bore careful watching.

SUMMER, 1932. The community house wading pool was less often used as the site of formal kindergarten photographs. Water, sun, and high spirits inevitably combined to inspire splashing, pushing, shoving, and jumping. Few students are identified by name as they frolic in the wading pool, but Coursen regularly documents their collective joie de vivre in photographs like this one.

HANDWORK CLASS, 1925. Margaret Pettyjohn taught a popular handwork class, which included woodworking, basket making, and leather crafting. Students made needle cases, billfolds, coin purses, key cases, and braided leather belts. "Handwork, stories and games," had stated Pettyjohn's predecessor Helen Fish in 1921, "are essential throughout the child's whole life, therefore we emphasize these activities in the playground and winter classes." (Photograph by John Horgan.)

HANDWORK FOR SALE, 1925. "The greatest end to be gained in handwork is the educational value of the work," stated Helen Fish. "Products of a handwork class may be purchased for a comparatively small amount of money, but the reasoning—judgment—accuracy and power developed through making cannot be purchased." Clearly the true value of arts education was not lost to WCH teachers. (Photograph by John Horgan.)

MOTHER GOOSE OPERETTA, 1937. The operetta features Peter von Storch as Little Boy Blue, seated at Mother Goose's (Crystal Stone) feet. In the second row, from left to right, stand Little Jack Horner (Billy Lewis), Jack jump over the candlestick (Louis Mastropasqua), and Little Red Riding Hood, who is cautious of the talking goose. Mary, Mary quite contrary (Margaret Thomas) and Dr. Foster (Ethel Mayo) stand directly on Mother Goose's left.

PHYSICAL EDUCATION DEMONSTRATION, 1937. One year earlier, director of physical education Wallace G. Rubright informed his audience at the athletic demonstration of 1936, "We portray a composite of the work of various classes. As individuals differ, so the ease and grace of performance will differ under your observation. But in general it will be the class as a whole which you observe and not any especially selected group."

PHYSICAL EDUCATION CLASS, 1929. Waverly High School physical education classes were held at the WCH. These students are wearing gym suits typical of the 1920s: some wear skirts while a few wear daring bloomers, and most model a loose blouse with a sailor collar. Girls played basketball and baseball during the spring and summer and bowled, sledded, and skied during the winter.

WOMEN'S BOWLING TEAM, 1925. During the 1920s, Waverly women formed a bowling league that played during the days and occasionally during evenings. By 1935, Henry Belin III could report, "Probably the most enthusiastic group during the past year has been the bowling crowd. The alleys have been in continuous use. League schedules have been played and replayed. We have enjoyed having this group at the community house."

WAVERLY BASKETBALL TEAM, 1945. Coach Michaels (second row, far left) and manager Bob Kester (second row, far right) flank their team in 1945. From left to right are (first row) Harry Lowroski, Jim Johnson, Bob Dixon, Henry Platt, Harry Purcell III, and Drake Vosburg; (second row, between Michaels and Kester) Austin White, Ben Stone, and Bob Rosengrant. (Courtesy EDL.)

WAVERLY HIGH SCHOOL BASKETBALL TEAM, 1941. Coach Johnny Childs (far right) poses with his team in 1941. Three years earlier, the WCH had appealed to the Waverly School District to reimburse the community house for expenses incurred by the school, which used the WCH gymnasium for practice and games. For the academic year of 1938–1939, the district approved an annual rental fee of $1,125.

RADCLIFFE CHAUTAUQUA PROGRAM, 1920. The first chautauqua held at the WCH was sponsored by the Radcliffe Chautauqua, which boasted of providing America with "Khaki-covered Education." The program asked community house participants, "Are you willing to work as hard to insure the safety of your government as the 'reds' are working to destroy it?"

HOMER B. HULBERT, 1922. Swarthmore Chautauquas were held more regularly at the WCH. During the 1922–1923 season, a ticket costing $1.50 entitled its holder to a lecture by Homer B. Hulbert, former employee of the emperor of Korea. Hulbert spoke on "When East Meets West" and asked his audience, "Do you know why Japan will never fight the United States?" Nevertheless, Japan bombed Pearl Harbor 19 years later.

GOING FISHING, 1926. Anne Avery saw to it that Saturdays offered special opportunities for boys to acquire hiking and fishing skills. WCH children who had learned to play together as kindergartners continued to do so into young adulthood.

Five

CREATING A COMMUNITY

WADING POOL, 1931. Children standing in the water of the WCH wading pool reveal its modest depths. In 1922–1923, the wading pool "brought much delight to the children and on warm days," Gertrude Coursen informed the trustees at their annual meeting, "we looked quite like Atlantic City with our varieties of red, green, blue and yellow caps and suits." The pool was a staple of summer frolic.

PLAYGROUND, 1931–1932. In the summer of 1923, Margaret Carpenter had supervised 100 playground sessions that brought 4,827 children to the community house. These numbers remained high well into the 1940s, especially with the arrival of summer residents and visiting friends during the summer months.

BASKETBALL PRACTICE, 1930. From WCH educators, trustees learned the larger goals of recreational and competition basketball: "The players should feel that a defeat resulting from an honest trial is part of the game, that the real issue is the amount of effort measured against the other players . . . The players are building traits of character, which will help them play fairly the game of life."

WAVERLY ATHLETIC ASSOCIATION, 1930. In February 1930, the Waverly Athletic Association sponsored a 275-yard toboggan run on the hill north of Stevenson's Pond. (Dr. Stone's house is in the background.) The run provided 14 seconds of daredeviltry to community house children: (from left to right) Ruth Burcher, unidentified youth, Helen Tyler, Val Jean Relph, and Gordon Wall. A hilltop bonfire lit by Boy Scouts warmed frosted toes and hands.

INTERNAL REVENUE RECEIPT, 1922. From the moment of its founding, the WCH sponsored theatrical and musical events, most produced in-house. Besides the Girl and Boy Scouts, 12 children's clubs were established by 1926, including the Little Theater Club and the Waverly Community Players. The Waverly Baptist and Methodist churches also presented plays in the WCH auditorium. This receipt allowed admission to be charged by all.

PIANIST MRS. CADWALLADER EVANS (1889–1963). A portrait of Mrs. Cadwallader Evans hangs in the east wing of the WCH. Painted by Lucy Hayworth Barker in 1939, it honors a woman who regularly lent her musical talent to the community house. When silent movies were shown at the WCH, she accompanied on piano. In 1922 alone, 44 movies were shown, which surely kept her fingers nimble and quick.

DANCE POSTER, 1922. Wescott Stone was instructor of old-time dancing in 1922. Regarding his work, Gertrude Coursen informed trustees in 1923 that old-time dances had become part of the WCH's monthly programming: "Twenty-two of these very popular affairs were given during the year. We were proud, indeed, when the dancing contest came and we realized how graceful and efficient many of our friends had become."

LITTLE THEATER, 1925. In December 1925, child actors of the community house's Little Theater Club produced *St. George and the Dragon*. In this photograph, the king at court learns that a dragon is menacing the countryside. Deliberation begins on how to rid the realm of the marauding, princess-devouring monster.

THE DREAM OF ST. GEORGE, 1925. As do many mythic heroes, St. George learns of his mission through a dream. A much-be-feathered dove speaks to sleep-dazed St. George. Sword at the ready, St. George accepts his mission to fight the dragon and rescue a princess.

DEATH OF THE DRAGON, 1925. In this photograph, the fierce dragon is wounded and spent, and cowers at the feet of noble St. George. The knight's sword has pierced its heart and the battle is finished. St. George raises his hand in victory.

LONG LIVE ST. GEORGE, 1925. The entire cast assembles to honor valiant St. George. The knight, in a time-honored pose of victory that entails foot poised on the head of a slain foe, receives the clamorous adulation of a relieved king and his courtiers. St. George, however, is admiring his happy rescued princess.

JUNIOR SPORTS CLUB, 1934. Junior Sports Club members paid 2¢ dues weekly and played games, hiked, and enjoyed treasure hunts. In 1929, they began to sponsor Clean Up Day, asking Waverly residents to have all refuse curbside by 7:00 a.m. Later Waverly's Boy Scout troop assumed this community-service responsibility.

ANNE AVERY'S SATURDAY MORNING CLASS, 1926. Anne Avery was an outdoors enthusiast who often took the young boys fishing, on overnight hikes, and on swimming excursions to Gravel Pond. In this photograph, the boys idly await their departure. Penned next to photographs of this 1926 fishing trip is Gertrude Coursen's coy statement "We are not saying how many fish we caught!"

87

```
WAVERLY ATHLETIC ASSOCIATION
       MARCH DANCE
              AT THE
       COMMUNITY HOUSE
    TUESDAY, MARCH 15th, 1927
        EDDIE MOORE'S ORCHESTRA

LADIES    -    -    -    -    FIFTY CENTS
```

MARCH DANCE, 1927. A 50¢ ticket admitted ladies to the Waverly Athletic Association's March dance, one of many held at the community house. Dancing was a "sport" much encouraged among youngsters by Gertrude Coursen, Helen Fish, and Ruth Harrison. Children were instructed in folk dancing because, as Helen Fish stated, it required "speed, agility, accuracy, lightness of foot, readiness of hand, and the ability to be quick in both thought and action."

```
              CONCERT
     AT WAVERLY COMMUNITY HOUSE
              WAVERLY, PA.

   THURSDAY EVENING, SEPTEMBER 15, 1921
            AT 8:20 O'CLOCK

               BY THE
    LIEDERKRANZ CHORUS OF 60 VOICES
    UNDER DIRECTION OF PROF. JOHN T. WATKINS

ADMISSION    -    -    -    -    FIFTY CENTS
        PROCEEDS TO BE USED FOR
   EXTENSION WORK OF THE COMMUNITY HOUSE
```

TICKET, SCRANTON LIEDERKRANZ CONCERT, 1921. In September 1921, Prof. John T. Watkins directed Scranton's oldest singing organization of German American citizens in a concert at the WCH. The Liederkranz Choral Society was well known locally for aiding charities and fund-raisers through benefit concerts. Funds from this concert, for example, were earmarked for the WCH construction fund.

CIRCUS PERFORMERS, 1933. Both children and adults enjoyed masquerades and other costumed festivities at the WCH. In this photograph, he is "she" and she is "he" in circus costumes that belie the wearer's gender. Masquerades provided endless opportunities for children and their parents to refashion identities in handmade costumes and masks. Not stores, but sewing baskets and rag bags supplied materials for creativity.

CHILDREN'S CIRCUS, 1933. The children's circus, described by Gertrude Coursen as "a close rival to Barnum and Bailey," originated with Helen Fish. By 1933, it was produced under the auspices of the Waverly Girl Scouts and was an event much anticipated by both children and parents. Brightly bedecked bicycles substituted for elephants in the opening parade. Spectators watched a blur of young performers in exuberant motion.

CIRCUS PARADE, 1933. Even Joe Dixon and the WCH jitney got into the Barnum and Bailey spirit. Festooned with ribbons, the van joined bicycles and their young riders in a parade that circled the community house and park. On the community house sidewalks, crowds watched and cheered before retiring to WCH grounds to enjoy fun, food, and fearless feats.

GIRL SCOUT HIKER CAROL DECKER, 1929. Girl Scouting began in Scranton in 1917 and Waverly Girl Scout Troop 1 formed three years later. Most troop activities took place at the WCH, but overnight hikes to Gravel Pond were a favorite activity. The girls also spent weeks during the summer at the second-oldest continually operating Girl Scout camp in the United States, Camp Archbald on Lake Ely in Susquehanna County.

OVERNIGHT CAMPING AT GRAVEL POND, 1932. The rationale for Scouting that Helen Fish gave to WCH trustees in 1923—"The aim of scouting is to teach the happiest way how to combine patriotism, out-door activities of every kind, skill in different branches of domestic science and high standards of community service"—continued to inspire successive Girl Scout captains and their troops.

RUTH HARRISON AND WAVERLY GIRL SCOUT TROOP 1, 1929. In 1922, 21 of 27 Scouts had passed the Tenderfoot Test, thereby establishing a record of Scouting excellence maintained well into the 1930s. In this photograph, Girl Scout captain Ruth Harrison (topmost, center) poses with lieutenant Mildred Jenkins (far right), and Joe Dixon is in the van. The group also includes Scouts Irene Jordan, Helen Peck, Delna Decker, and Helen Burghauser.

HELEN PECK AND IRENE JORDAN, 1930. First-class Girl Scouts of Waverly had worked diligently to pass their Homemaker's Test in 1923 by planning their future house in a proper location, making a list of furniture needed (not wanted!), and knowing the current way to wash and iron and "the most economical way to buy and store food." These 1930 Scouts learned that household duties occurred on camping trips too.

GIRL SCOUT DRILL, 1925. In reports after 1929, Waverly Girl Scouts proudly related the history of their independent rallies where drills like this one of 1925 were performed: "Scout troops this side of the knotch [sic] have had 13 rallies instead of receiving their badges from the Scranton Girl Scout Rally. Each year a troop was hostess. The first rally apart from Scranton was held at the [Waverly] Community House."

SCENE FROM *A MIDSUMMER NIGHT'S DREAM*, 1926. A moonlit lawn in Waverly was the evocative site for a joint production by the Girl and Boy Scouts in Waverly of William Shakespeare's *A Midsummer Night's Dream*. The seventh annual Waverly Fair of 1926 opened as well with this theatrical production.

THE COURT OF OBERON AND TITANIA, 1926. The program for this nocturnal Shakespearian performance of September 2, 1926, opened with "The Scouts of Waverly invite you to share their 'Mid-summer Night's Dream.' Dreamed in this sylvan glade / Sometime in the garden of the Stately Duke / Sometime in the Bower of lovelorn youth / A magic moonlit spot—the Haunt of roguish fairies."

93

GIRL SCOUT PANTOMIME, 1927. Under Anne Avery's and Gertrude Coursen's expert direction, and in order to raise enough money enabling every Waverly Girl Scout to attend Camp Archbald for one week during the summer, Scouts staged a festival in May 1927. The event opened with a grand march followed by French pantomime, a minuet, a maypole dance, and the ceremonial crowning of the May Queen.

MASQUERADE DANCE, 1924. For this masquerade, Girl Scouts Gethen Williams and Elizabeth Fish are dressed in 18th-century Colonial attire and pose outside the WCH. The redbrick architecture of George M. D. Lewis proved a fitting setting for their polite antics that preceded the dancing.

MAY FESTIVAL, 1927. During the festival that was staged on the grounds of the community house, Waverly's May Queen received her crown. Susan Wheeler is the regal lady attended by two proper pages, Arthur Welles and Tony Mastropasqua. Queen Susan is also accompanied by a slightly distraught flower girl with an over-large bouquet, Janice Decker.

IRISH FOLK DANCING, NAY AUG PARK, 1925. While the Boy Scouts staged displays of balance and control, Girl Scouts demonstrated athletic prowess through folk dancing. Physical health was integral to Scouting as a philosophy of exercise, survival training, and recreation. For this festival, Ellen Fulton (Century Club) provided music and Mary Brooks Picken (Woman's Institute of Domestic Arts and Sciences) supplied some of the costumes.

VIEW FROM BALD MOUNTAIN, 1929. Waverly Girl Scouts hiked Bald Mountain in 1929, departing from the WCH in the community house bus chauffeured by Joe Dixon. Lunch atop the mountain yielded not only respite but a commandingly beautiful panorama of the Lackawanna Valley.

LAKE TINGLEY, SUMMER 1930. Ruth Harrison accompanied the Scouts to Lake Tingley, near Harford. Scout Donna Edwards described the four-day trip: "We rented a cottage and were allowed a boat with it. Mrs. Tyler went along to help the girls in preparing the meals and Miss Harrison was the chaperon." From left to right are Helen Peck, Irene Jordan, Helen Burghauser, Helen Wall, Delna Decker, Jean MacFarland, and Dorothy Dearborn.

FALLS, SUMMER 1937. Junior Girl Scouts picnicked and swam in Falls during September 1937. On this hot day of late summer, the cool water is welcome but startling relief to these joyous water sprites. During the year, the Scouts enjoyed movies such as *David Copperfield*, *Little Lord Fauntleroy*, *Old Kentucky*, and *Captain January*.

HANDWORK CLASS, 1931. Children of all ages enjoyed Ruth Harrison's handwork classes. This professional photograph by Scranton's Hornbaker Studio was published in the newspaper to inform readers of the many craft activities offered by the WCH. The range of handwork here displayed includes chair caning, basket making, and weaving. Ruth Harrison averred that few products made it past the children's proud parents to Waverly Fair sale booths.

COSTUMED MOTHERS AT BASSETT POND, 1931. The Mother's Club was organized in July 1928 by Genevieve Linen, wife of James Linen, as the Girl Scout Mothers' Club, but five months afterward, the organization opened to all Waverly mothers. Club goals were "to unite the influence and interests of the mothers of Waverly to promote training for children, parents and homemaking, and to aid in the extension of village improvements."

JULY 1929. It was not all work and no play in the Mother's Club. The annual picnic took place in June at nearby sites like Bassett Pond. Like their Scouting daughters, mothers enjoyed hikes, picnics, and camping outdoors—when they were not collaborating with Scranton's Welfare Association, the Parent-Teacher Council of Lackawanna County, the Scranton chapter of the American Red Cross, or the Big Sister Organization established by the Century Club.

PROGRAM, WAVERLY WOMAN'S CLUB, 1929–1930.
The Waverly Woman's Club comprised 27 members in 1929–1930. A president and her officers directed this typical women's club of the early 20th century. The organization comprised self-improvement and activist departments: music, literature, American home, and current events. Today's Waverly Woman's Club operates the Attic Shop in the WCH basement as a fund-raiser for the community house.

WAVERLY WOMAN'S CLUB
PROGRAM
1929-1930

OFFICERS
President............Mrs. Ralph G. Young
Vice-President........Mrs. F. B. MacFarland
Secretary............Mrs. McKinley Parker
Corresponding Secy....Mrs. E. S. Stone
Treasurer............Mrs. Carroll Dean

Lackawanna County Federation News

OUR POLICY: In the little things we may differ, but in the big things we are one.

WEATHER: It's always fair weather when good friends get together.

LARGEST CIRCULATION OF ANY UNPUBLISHED NEWSPAPER IN THE WORLD

Vol. I—No. 1 ESTABLISHED MAY 15, 1929 PRICE FREE To Members and Friends

COUNTY BEAUTIFUL EDITION

THIRD ANNUAL MEETING

LACKAWANNA COUNTY FEDERATION OF WOMEN'S CLUBS
DALTON METHODIST EPISCOPAL CHURCH
WEDNESDAY, MAY 15, 1929
DALTON WOMAN'S CLUB, Hostess

Morning Session
TEN-FIFTEEN O'CLOCK

CALL TO ORDER..............................MRS. J. E. SICKLER
 Acting President
"HAIL PENNSYLVANIA"........MRS. EARL V. TOLLEY, Accompanying
INVOCATION................................REV. EARL V. TOLLEY
 Pastor Dalton M. E. Church
ADDRESS OF WELCOME........................MRS. HARRY DEAN
 President of Hostess Club
RESPONSE...............................MISS MILDRED PATTERSON
INTRODUCTION OF GUESTS
FEATURE ARTICLES—See Page Three
ADJOURNMENT FOR LUNCHEON
LUNCHEON MUSIC............................MRS. L. W. HAZLETT
 Organist of Baptist Church

LACKAWANNA COUNTY FEDERATION OF WOMEN'S CLUBS, 1929. The Waverly Woman's Club hosted the third annual meeting of the Lackawanna County Federation of Women's Clubs during the summer of 1929 at the Dalton Methodist Episcopal Church. The topic of the meeting chaired by Scranton clubwoman Caroline Patterson Sickler was "County Beautiful," and the women addressed issues of roadside forestation and billboard restriction.

99

BOY SCOUTS AT CAMP, 1933. Boy Scouting was chartered in Scranton in 1916, and the greatest advance for the local movement came with the formation of the Scranton Area Council in 1928 that brought 1,000 young men from four counties (Lackawanna, Pike, Wayne, and Susquehanna) and approximately 35 new troops into a regional fold. Waverly Troop 1 belonged to this council.

SCOUT DRILL, 1925. The first Boy Scout troop chartered in the Abingtons was Clarks Summit Troop 1, against which Waverly Troop 1 competed in annual drill and discipline contests held at the community house. In 1939, each troop was inspected by army officers, and points were awarded on drilling (as seen here), attendance, and appearance. From 1931 through 1938, Clark Summit Troop 2 won the blue banner of victory, much to Waverly's chagrin.

SCOUTMASTER VON STORCH, LAKE TINGLEY, 1933. Searle von Storch (second from left) replaced Franklin MacLaren as scoutmaster in 1932. The annual report submitted by Waverly Boy Scout Troop 1 at the yearly WCH meeting of 1933 acknowledged the boys' debt to MacLaren. Additionally, the troop projected an active summer canoeing on the Susquehanna River and camping again at Lake Tingley.

WAVERLY SCOUT TROOPS, 1925. Waverly's two Scout troops, boys and girls, often collaborated to present WCH programs. They participated in rallies (the awarding of badges), produced plays together, ushered at special events, cosponsored fund-raisers for the WCH, and annually led the Waverly community in Memorial Day ceremonies.

ASSEMBLY ON THE WCH PARK, 1935. Scout troops gather, band members organize, and a subdued crowd forms at 11:15 a.m. for a morning of ceremony and remembrance. Waverly's Memorial Day procession concluded in Hickory Grove Cemetery where early generations of villagers were buried, including Elder John Miller and survivor of the Wyoming Massacre Deborah Bedford.

MEMORIAL DAY AT THE WCH, 1935. After climbing the steep ascent of Academy Street, Waverly residents processed into Hickory Grove Cemetery. A representative from Scranton's De Lacey Tent Daughters of Union Veterans laid wreaths, an invocation was given, and throughout the ceremony Waverly Boy and Girl Scouts sang and marched.

CAROLING ANNOUNCEMENT, 1927. Caroling by Waverly Boy and Girl Scouts began on Christmas Eve at the foot of the community Christmas tree donated each year by the Waverly Grange. In 1926, the program included familiar songs: "O Come all Ye Faithful," "Hark! The Herald Angels Sing," the "Cradle Hymn" ("Away in a Manger"), "It Came Upon a Midnight Clear," and "The First Nowell [sic]."

𝔈𝔞𝔯𝔬𝔩𝔢𝔯𝔰 will stop at your house between 6 and 7:30 on Christmas Eve if you place a lighted candle in your window
A Merry Christmas from the Girl and Boy Scouts

WAVERLY SOLDIERS, 1944. Two years earlier, WCH trustees had observed, "These are probably the most serious days that any citizen of this country has lived through since the time of the Civil War . . . [We] feel that for the duration our biggest task is the fullest cooperation with the Defense Effort, and to this end we dedicate the use of every facility of the [WCH] and its staff."

AFGHANS FOR ENGLAND, 1943. While Brownies and Junior Girl Scouts knit afghans for England, other WCH members sent newsletters to Waverly's soldiers. Newsletter No. 4 (1943) quipped, "The Nazis are advancing at a very rapid rate toward Germany; Hitler has apparently lost his intuitive powers and was 'too busy' directing this 'advancement' to appear at the recent anniversary; Musso[lini] has canned his stepson and the 'Japs' have left Guadalcanal."

OFFICIAL SALVAGE DEPOT, 1942. The WCH sent a notice to Waverly residents in March 1942, asking that all tin cans and discarded license plates be set aside for collection by Waverly Scout troops. "Save All Old Razor Blades and Toothpaste Containers," the notice advised, since "the value of these items is very high." Defense activities were posted on a bulletin board in the WCH lobby.

Six

The Waverly Fair

WAVERLY FAIR, 1927. From 1920 through 1937, the Waverly annual flower and vegetable exposition and fair was an integral part of community life. Production of the first Waverly Fair in 1920 entailed collaboration between WCH staff, community house clubs, the Waverly Grange, resident farmers, local churches, and village adults and children. Everyone in Waverly labored on one of the many fair committees.

TICKET BOOTH, 1932. The first Waverly Fair opened on October 7, 1920, as a two-day event. The *Scranton Times* described the enterprise with admiration: "The spirit of the [Waverly] Community House is responsible for this interesting epoch in the life of the village and the interest shown by the people of the Abingtons and many from Scranton is evidence that the fair is something that will not soon be forgotten."

VEGETABLES ON DISPLAY, 1925. The Waverly Fair was envisioned "to promote healthy rivalry, [and] an exchange of stock, produce, canned vegetables, fruits, flowers, etc." In 1921, WCH trustees had invited participants by letter, boasting, "The Community House stands for the betterment of everything from man to onions." This display of local produce was arranged in the WCH auditorium.

JOSEPH CARPENTER'S PUMPKIN, 1920. Following the fair of 1921, local composer Bertha Colvin Lister complained to the trustees: "What a pity not to have the mental side of the Abington people represented in some way. The song 'Abington' should be in evidence there somewhere, as it is every bit as hard to write a song as to grow a huge pumpkin or fat swine."

GETTING TO THE WAVERLY FAIR, 1931. Waverly Fair workers did not limit their festival chores to the community house grounds. A fleet of automobiles volunteered by villagers was organized initially to transport visitors free of charge to the fairground. At first, cars set out for the Clarks Green railroad station. Ten years later, buses were departing from Scranton's Courthouse Square.

DINING AT THE FAIR, 1936. The cafeteria menu in 1922 included potato salad; wieners; ice cream; small cakes; ham, cheese and olive, and egg sandwiches; coffee; clams; and corn on the cob. By 1936, Waverly women were serving a full-course dinner in addition to sandwiches and waffles. All food was prepared by Waverly women for days before the fair opened.

HELEN FISH, JAMES WALSH, AND GERTRUDE COURSEN, 1923. *Scranton Times* cartoonist James Walsh regularly attended the Waverly Fair and drew caricatures of WCH committeemen and committeewomen. At the three-day fair of 1923, Helen Fish (left) and Gertrude Coursen devoted much effort to the new exhibition of antiques and objects of historical interest besides the usual displays of birdhouses, quilts, fancywork, and flowers.

MIDWAY, WAVERLY FAIR, 1929. Although this view of the midway in 1929 is quiet, such was not the case for the three crowd-packed days of the Waverly Fair. In the WCH Archives, a list of committees for the seventh annual fair (1926) reveals the range of fun traditionally planned for the midway: a dunking tank, dart games, fortune telling, weight guessing, "hit the coon," a vaudeville show, a Japanese tea shop, and pony rides.

HANDWORK BOOTH, 1925. The *Scranton Times* reported in 1927 that "the work of the children done on the playground shows a wide variety of interest and ability. Trays, baskets, doll cradles, woven belts, mats for hot dishes, and many other useful things are shown all for sale, and orders will be taken when the supply runs out."

ICE-CREAM VENDORS VAL JEAN RELPH AND JANET MACDONALD, 1931. The amount of work that WCH workers put into the fair can be measured against this creative booth. It is made entirely by hand with available materials. Once made, booths like this one required storage space in the WCH that necessitated the addition of wings to the community house in 1930.

RINGMASTER ANNA BLISS MACKEY, 1927. Dr. N. C. Mackey's wife, Anna Bliss, directed the children's circus as ringmaster in 1927. Other entertainers included Waverly-ites masquerading as Topsey; the Siamese twins; Jo-Jo and his monkey; a tightrope walker; Madame Spreadaround, who weighed 600 pounds; the tallest woman in 49 states (also known as Wilbur Carpenter); the dwarf lady; and Zu Zu the snake charmer.

MAIL CARRIER WARREN BERRY WITH MRS. C. H. GRIFFIN, 1923. For Warren Berry and others, the climax of the fourth Waverly Fair was the carnival on Saturday afternoon followed by an evening dance in the auditorium. The *Scranton Times* promised that "flappers will be welcome to flap to their heart's content, and Lawrence's band will supply the kind of music which just won't let your feet behave."

CLOWN BOOTH, 1925. The general committee of the 1924 Waverly Fair chaired by Aline Besancon and George M. D. Lewis directed a plenitude of committees: publicity, lighting, equipment and sound, transportation, cleanup, advertising, homemade candy and cake, ice cream and soft drinks, dance, baked and canned goods, fancywork, waitresses, children's booth, and the clown booth committee that supplied merry fellows such as these.

FERRIS WHEEL, C. 1937. In addition, Aline Besancon and George M. D. Lewis supervised committees for parking, tickets, house decoration, food, popcorn, peanuts, paint, hospitality, flower selling, vegetable selling, grabs, ponies, obstacle golf, bowling green, sideshow, balloons, fishpond, flowers, historical display, agricultural display, selling toys, fortune teller, and that ubiquitous festival toy—the Ferris wheel.

MADELINE SMITH, 1925. The invitation to the fifth annual fair (1924) proudly stated, "The Fair will be just a plain old fashioned Country Fair and Flower Show, and will have none of the objectional [sic] money-making concessions to outsiders. It is entirely a Waverly production . . . conducted by its people in the entire interest of the Waverly Community House. Every person in Waverly has his part," including young Madeline Smith.

GARDEN DISPLAY, 1925. Waverly's sixth annual fair brought a distinguished juror to Waverly. Of editor Richard Wright (*House and Garden* magazine), Gertrude Coursen wrote that he "soon became a friend of Waverly and was so impressed by the way in which Waverly people were doing things that he was delighted to have the privilege of printing in his magazine an outline of the activities here." (See December 1925 issue, page 79.)

EXHIBITION OF FORMAL GARDENS, 1934. A remarkable garden exhibition was arranged for the fair of August 22–24, 1934. An entire portion of the community house park was laid out in formal gardens according to the plan devised by a "prominent New York landscape architect" (his name remains unknown). Northeastern Pennsylvania's leading nurseries and commercial florists collaborated with Aline Besancon in staging this grand display of plants and flowers.

FLOWER DISPLAY IN AUDITORIUM, 1927. "Entering the auditorium," reported the *Tribune Republican*, "one could visualize himself stepping into the realm of a fairyland. Flowers of all species—from the tints of autumn, rust and gold—blending with the dusty greens of the field—gorgeous and beautiful in their god-like appeal—transformed the room into a setting of extreme grandeur."

MARGARET CARPENTER, 1925. At the 1925 fair, the WCH historical committee designed exhibits documenting historic times in the community. Behind Margaret Carpenter is a spinning wheel that belonged to chairperson of the exhibition committee Ida Cowles. It had been transported to Waverly from Connecticut by her ancestors 150 years earlier. (Photograph by John Horgan.)

SGT. GEORGE PERRY, GRAND ARMY OF THE REPUBLIC, 1924. A special feature introduced to the Waverly Fair was old home day. Waverly's "old in years and young in spirits" received a personal invitation to return to the village. They were asked to bring their memories and any items reflecting Waverly's past. Former school pupils, principals, teachers, and veterans—all born before 1888—were urged to attend.

THE JAMES LINEN VICTORIA, 1934. Dressed in the attire of yesteryear, these women arrive in style at the fair of 1934 in the Linen family's Gay Nineties victoria. During this fair, a room in the WCH was created to represent the original dining room and bar of Jeremiah Clark's Tavern, built 137 years earlier. The combined age of Waverly's returning "old-timers" this year was 1,800 years.

OLD HOME DAY COMMITTEE, 1932. Helen von Storch (far left), Margaret Carpenter Stone (far right), and Constance Reynolds Belin (third from right) were among the committeewomen who served as hostesses for the older attendees at the fair. They matched their duties with clothing from earlier days and made WCH living history part of the festivities.

THE "YOUNG AT HEART," 1937. This photograph taken on the fairgrounds of the WCH commemorates the large number of older-generation Waverly-ites who journeyed to the 1937 fair. One intrepid octogenarian walked from Dalton to the WCH, a mere stretch of the legs for Waverly's hardy pioneers.

OLD HOME DAY ANTIQUES DISPLAY, 1934. The Scout room in the WCH was also transformed during the annual fair. Members of the community contributed items from their family collections, which were exhibited in the form of settings from past times. Among the objects displayed in this room are clothing, small works of art, and a spinning wheel.

OLD HOME DAY BOOTH, 1937. The old home day booth of 1931 presaged this booth of 1937 in reproducing a pioneer home. Elder John Miller's granddaughter Mrs. George Stevenson traveled from her home in Florida to Waverly in 1931. Old-time music was played at lunchtime to Waverly's oldest, from age 80 to 93 years, and a prize for the oldest attendee was awarded to Mary Mead, age 93.

SKETCH OF SOUTH FRONT, GEORGE M. D. LEWIS, 1929. The annual fashion show staged on the WCH south staircases (that no longer exist) was a special event for Waverly's girls and women who modeled clothing provided by Scranton merchants Heinz, Oppenheim, and Cleland-Simpson. Miss Scranton 1926 Ilya Williams modeled clothing in 1927 and, in 1936, Scranton screen star Jeanne Madden flew in an airplane over Scranton inviting all to the fair.

ALINE BESANCON, C. 1930. During the 1931 fair, the children's wading pool was transformed into a lily pond designed by Scranton florist and longtime supporter of the WCH Aline Besancon. Sophisticated arrangements of flowers were displayed at the fair by professionals and amateurs, but Besancon did not neglect the children. She created an opportunity for their burgeoning floricultural talents by exhibiting children's flower arrangements.

WAVERLY GARDENERS ON PARADE, 1929. An artistically arranged display of large and beautiful vegetables, as seen in this photograph, was always a central component of the Waverly Fair. In 1932, the Waverly Fair committee also allotted exhibition space to Scranton's Red Cross Garden Committee for a special display of produce grown from Red Cross seeds in the city's "Thrift Gardens."

FORMAL DINING TABLE DISPLAY, 1934. Flower centerpieces and table settings were a category that drew the attention and creativity of Waverly women, who brought out linens and lace, candlesticks and silverware, china and, of course, flowers from their gardens for judging. Prizes were bestowed as ribbons, cash, and silver cups.

Garden Beds, 1930s. The avenue of trees that screened the community house from Clinton Street is visible in this photograph. Not only did the garden displays created for the fairs supply ideas for creative gardeners, but they also provided isles of respite and quiet beauty apart from the fair's general mayhem.

BIRDBATH GARDEN DISPLAY, 1930s. Garden displays were usually arranged thematically. In this instance, a birdbath is the central design motif shared by this set of competition displays. One industrious competitor clearly abandoned the stone bath for a simulated pond with natural, rustic landscaping.

EXHIBITION PROGRAM, 1931. By 1931, the WCH was publishing a souvenir brochure containing competition categories in flower and vegetable judging, advice from gardening experts, photographs of Waverly gardens, and the schedule for three days of fair events. Advertisements in the program document Waverly farms and businesses and identify local and Scranton sponsors.

SCHEDULE OF THE
12th Annual Fall Exhibition
Farm and Home Products
and Flower Show
WAVERLY AND VICINITY

Waverly Community House
August 20, 21 and 22
1931

FLOWER BED EXHIBITION, 1930S. This photograph reveals the considerable amount of time and effort the Waverly community devoted to setup for the fair. By the 1930s, more professional gardeners were submitting designs and displays for judging, so much so that judges were asked to assess professionals and amateurs separately.

COMPETITION TERRACE GARDENS, 1930S. Dressed in their summer whites, these fair attendees contemplate an exhibition of terraced flower beds. This was an informative exhibition for Waverly gardeners often faced with the challenging task of planting a garden on and around the hilly terrain of the Abingtons' countryside.

FAIR BOOTHS, 1930. A temporary white picket fence separated high traffic zones of booths and dining tables from competition garden displays. Although the effect appears to be permanent, the row of tall shrubs and low plantings set alongside the fence are purely temporary.

WEST WING, 1930. The original lawn of the WCH was graded to slope down from the front to the rear lawn (today a parking lot occupies the low ground in this photograph). One suspects that master gardener Aline Besancon had a hand in sculpting the staired descent with flowers and plants.

JAMES WALSH CARICATURES, 1930S. *Scranton Times* cartoonist James Walsh enjoyed observing Waverly Fair committeemen and committeewomen. Depicted in this drawing are Robert Winsip, John Hill, Wilbur Carpenter, "Miss Coursen," "Miss Fish," Helen Snow, Frank Smalzer, Floyd Berry, Clare West, Benton Smith, Monroe Siptroth, Harry Miller, and Frances Oakford.

PAUL B. BELIN CARICATURE, 1924. Chairpersons George M. D. Lewis and Aline Besancon top this set of caricatures that presents Paul B. Belin of the cleanup committee vacuuming below. Walsh includes as well Mary Linen, Ward Severance, Elizabeth Crellin, Johnny Miller, Warren Berry, Frank Smalzer, George Perry, Horace Luce, and Howard Stone.

Fairground Gardens, 1935. Ambition to outdo the previous year led to grander endeavors, and the Waverly community finally wearied that had so earnestly constructed booths, wired electric lights, sewed costumes, staffed booths, and cooked for 17 years. The fair never faded slowly or became anything short of wonderful during the 17 years of its existence. It was retired as a fund-raiser by the trustees in 1938 and is remembered by few in Waverly save those born during the opening three decades of the 20th century.

EDWARD J. AND RACHEL STONE, 1937. In her annual reports, Gertrude Coursen often revealed a poetic depth of feeling for the higher purpose she served at the WCH. Often this took the form of verses that she included in her report. One elegiac poem by Sam Walter Foss begins, "Let me live in a house by the side of the road / Where the race of men go by . . ."

WCH North Front, 2008. And, Foss concludes, "The men who are good and the men who are bad / As good and as bad as I. / I would not sit in the scorner's seat / Or hurl the cynic's ban: / Let me live in a house by the side of the road, / And be a friend to man." The thought honors Margaretta L. and Henry Belin and the special magic of their Waverly Community House.

BIBLIOGRAPHY

Belin, Gaspard D'Andelot. "Belin Family." Undated manuscript. Lackawanna Historical Society, Scranton, PA.

Coursen, Gertrude. Scrapbooks, 1920–1948. Waverly Community House Archives, Waverly, PA.

Garrett, Emma. "Letter, Emma Garrett to Alexander Graham Bell, October 29, 1883." Alexander Graham Bell Family Papers. Library of Congress, Washington, D.C.

Hitchcock, Colonel Frederick Lyman. *History of Scranton and Its People*. 2 vols. New York: Lewis Historical Publishing Company, 1914.

Horgan, John. Photographs, Waverly Community House, 1920. Waverly Community House Archives, Waverly, PA.

Lewis, Anne Davison. *Echoes in the Hills*. Scranton, PA: University of Scranton Press, 2003.

Lewis, George M. D. Architectural drawings, 1920. Waverly Community House Archives, Waverly, PA.

———. *Dear Bert*. Compiled and edited by Edward Davis Lewis. Trento, Italy: Lo Gisma, 2002.

———. "Historical Notes on Waverly." Undated, typed manuscript. Lackawanna Historical Society, Scranton, PA.

Mumford, Mildred. *This Is Waverly*. Waverly, PA: Waverly Woman's Club, 1954.

Murphy, Thomas. *Jubilee History: Commemorative of the Fiftieth Anniversary of the Creation of Lackawanna County, Pennsylvania*. 2 vols. Topeka: Historical Publishing Company, 1928.

Peck, Rosamund, and Susan S. Belin. *Taste of Waverly*. Waverly, PA: Waverly Community House, 1986.

Twining, Alfred. "Historic Abingtons." *Scranton Times*, October 1920.

Across America, People are Discovering Something Wonderful. Their Heritage.

Arcadia Publishing is the leading local history publisher in the United States. With more than 3,000 titles in print and hundreds of new titles released every year, Arcadia has extensive specialized experience chronicling the history of communities and celebrating America's hidden stories, bringing to life the people, places, and events from the past. To discover the history of other communities across the nation, please visit:

www.arcadiapublishing.com

Customized search tools allow you to find regional history books about the town where you grew up, the cities where your friends and family live, the town where your parents met, or even that retirement spot you've been dreaming about.